Geometrix Book One

LOUISE ATHERTON

© 2017 Louise Atherton
louiseatherton.com

All rights reserved.
ISBN: 1545408475
ISBN-13: 978-1545408476

GEOMETRIX BOOK ONE

Testing – Use this page to test your writing implements and color palettes.

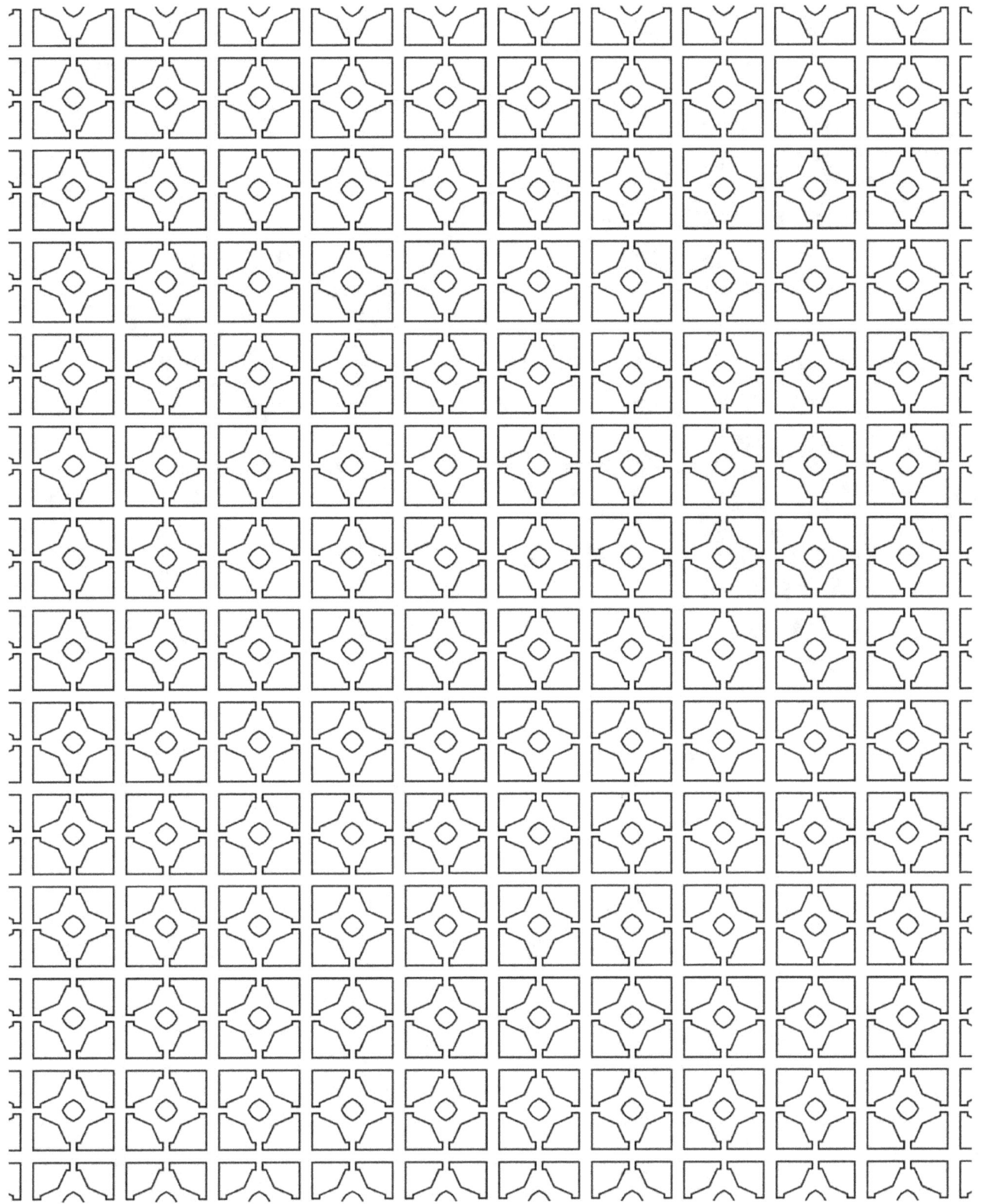

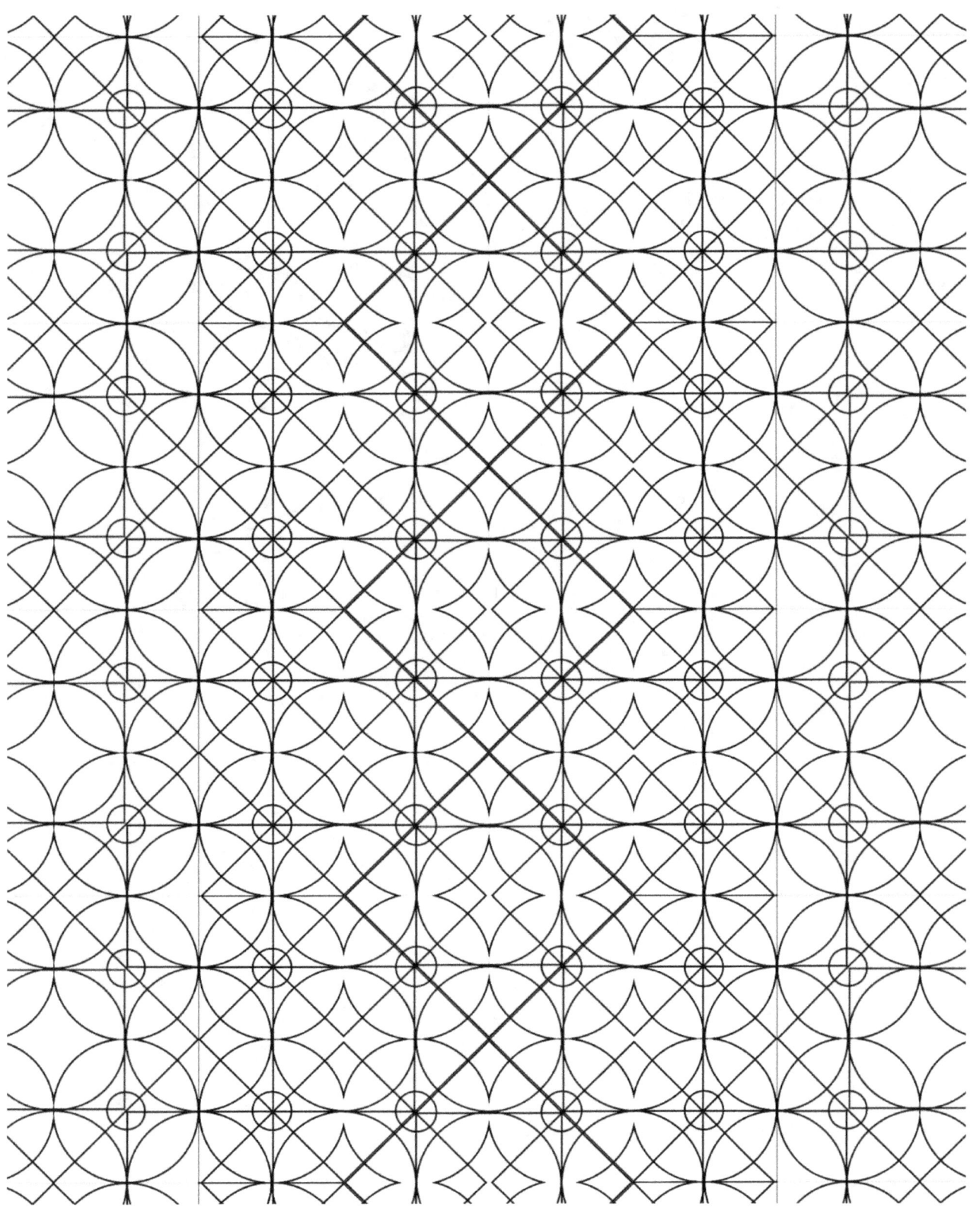

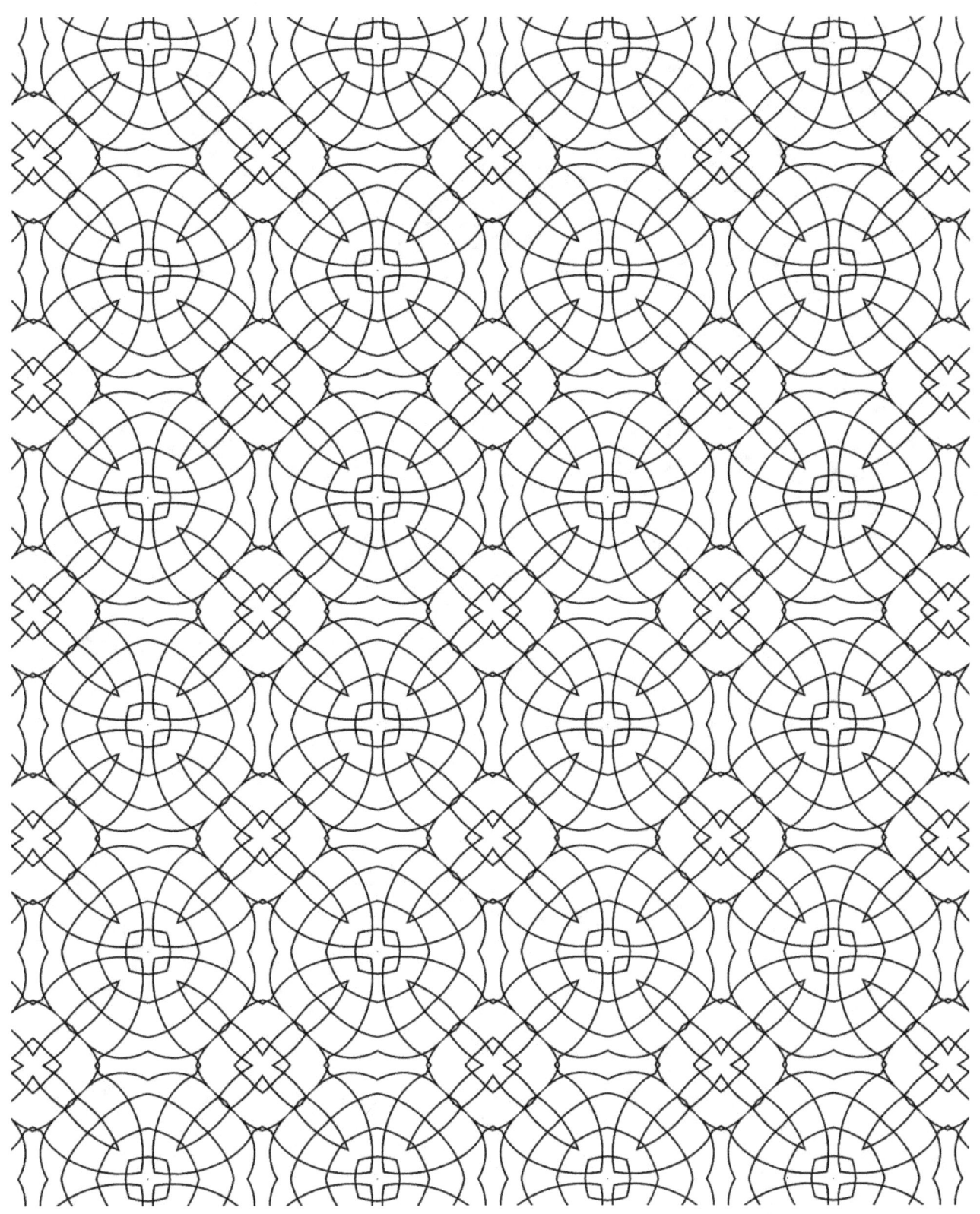

GEOMETRIX BOOK ONE

www.ingramcontent.com/pod-product-compliance
Lightning Source LLC
Chambersburg PA
CBHW081121180526

45170CB00008B/2957